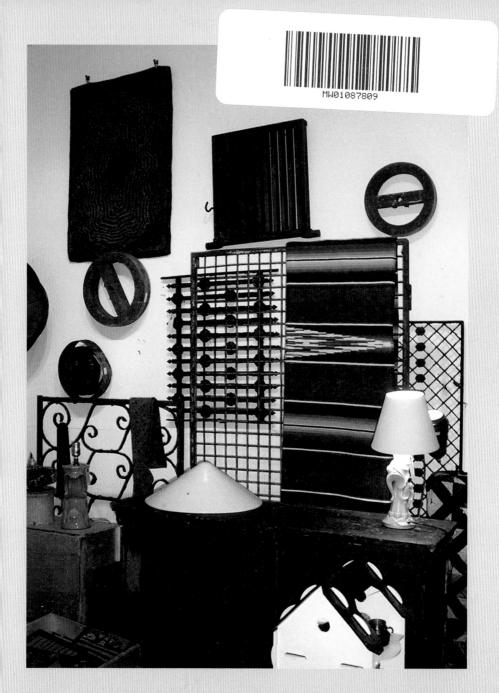

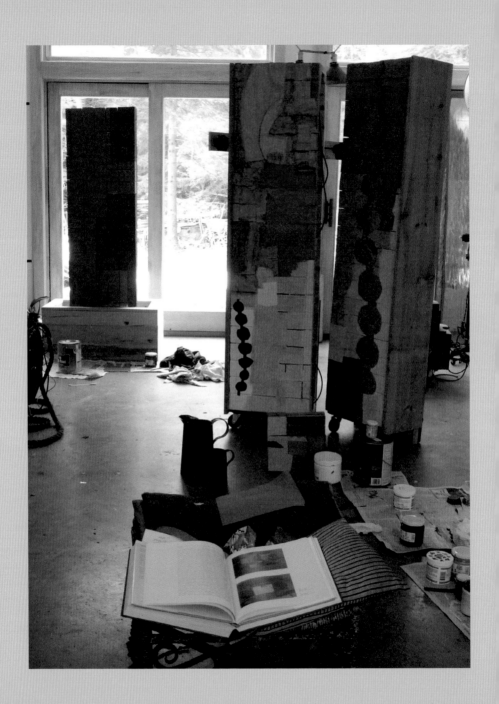

Henry at Home

Soberscove Press
1055 N. Wolcott, 2F
Chicago, IL 60622
www.soberscovepress.com

Many thanks to the shopping public
that has kept Henry in business for 12 years,
everyone who agreed to be part of this project,
Hudson of Feature Inc., who started it 3 years ago,
Ann Bobco who designed it,
Julia Klein who finished it,
and always to Jackson.
Nancy Shaver

Thanks from Soberscove Press to Ann Bobco, Hudson of Feature, Inc.,
Marteinn Jónasson of Oddi Printing, Lucy Raven and Steel Stillman
for their conversations and contributions, as well as to all of the owners
and photographers of Henry objects. Of course, the biggest thanks to
Nancy Shaver, without whom this book could not and would not exist.
Julia Klein

Front Cover: Home of Lynn Sloneker and Stephen Courbois
(painted footstool, lamp and textile). Photo: Lynn Sloneker.
. Back Cover: *Covered Chair*, 2004, Nancy Shaver. Photo: Jason Mandella.

Book Design by Ann Bobco.

Printed in Iceland by Oddi Printing.

ISBN-13: 978-0-9824090-1-5

Henry at Home

Soberscove Press

A BRAND ON MY BRAIN, SHAPED LIKE A SOCK

If your subject has no limits, how do you put a rectangle around it and make it into something to sell?

Well, last fall, on a wall, the Met said: Henri Matisse could not stop thinking about this painting [Paul Cézanne (French, 1839-1906) *Three Bathers*, 1879-82 Oil on canvas, Petit Palais, Musée des Beaux-Arts de la Ville de Paris] after seeing it at Vollard's gallery in 1899. Despite his limited means, he returned to the rue Laffitte and purchased it, along with Rodin's plaster bust of the politician and author Henri Rochefort. Thirty-seven years later, long after he himself had become famous, Matisse acknowledged that *Three Bathers* "has sustained me morally in the critical moments of my venture as an artist; I have drawn from it my faith and my perseverance."

The switch from past to present perfect tense in the caption, and from third to first person, was unexpected/has occurred when the painting gets purchased by Matisse. The tense shifts when the object changes hands. And around that very moment hovers a peculiar aspect of the present that hits us now, years later: the first instant of keeping something in mind. The initial encounter with the thing you can't stop thinking about. A thing that earlier was

made, and later has been found, and now won't go away.

Close up, a collection of such instants might look like pieces of amber, or furniture meant to be moved. Of human size and snug proportions, touching with each preposition. Like Polaroids made of wood and cloth. On wheels. Arranged to be encountered and held in the mind. Displayed to be exchanged or sorted through like snapshots. For sale to be taken away to make room for something else, because no one can hold more than her memory's girth, so we have to trade.

Meanwhile, if these instants are still around—

Objects to fall asleep thinking about: silver x's; patchwork squares; a craft cross fashioned from popsicle sticks; price tags attached by string to a rod like a giant pinecone; painted blocks stacked on shelves.

Things to wake up with: painted blocks stacked on the floor; men's ties wrapped taut around a cinderblock; candle-flame lightbulbs lined up at different heights like musical notes; silk turbans.

In the in-between: black electrical cord; two storefront windows; the good night you sold the rug.

Lucy Raven

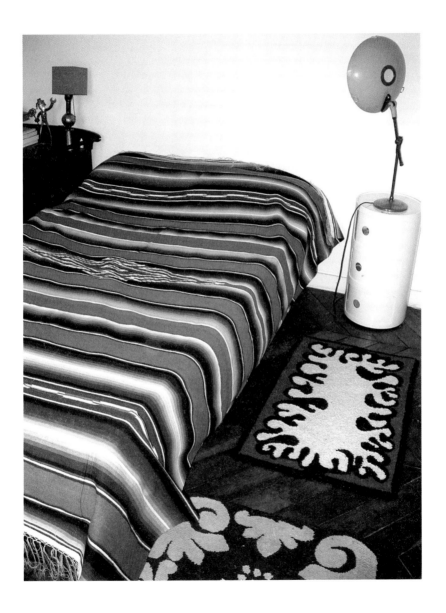

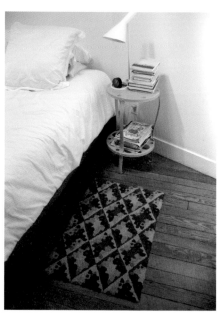

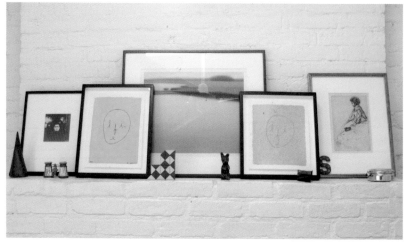

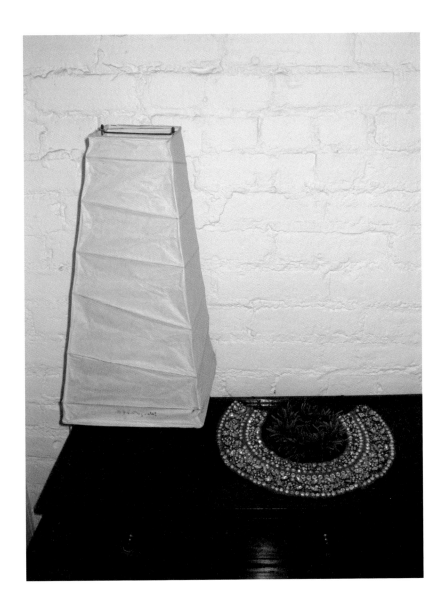

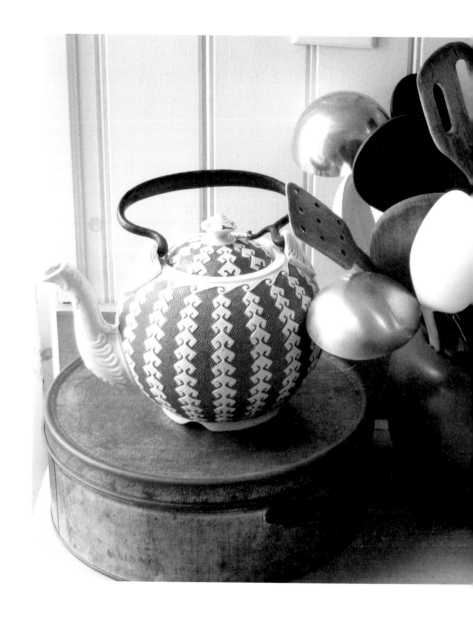

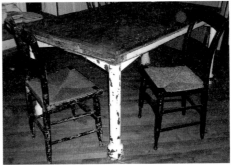

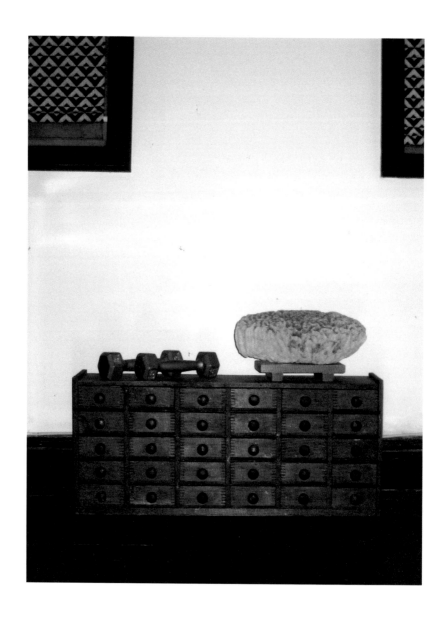

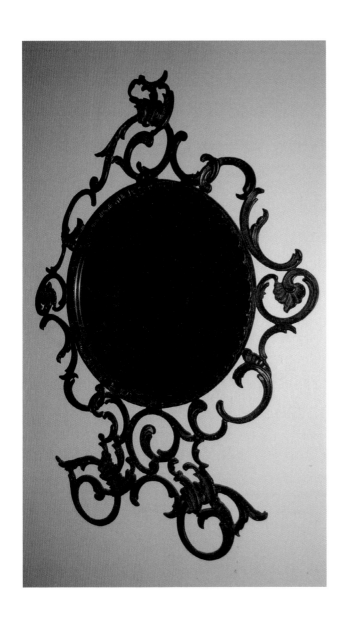

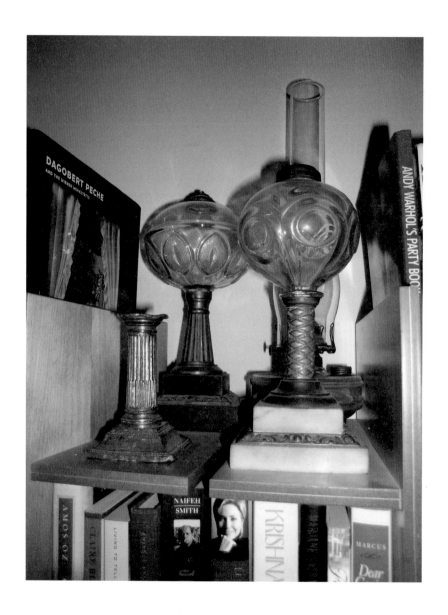

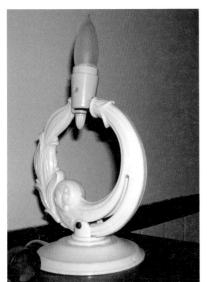

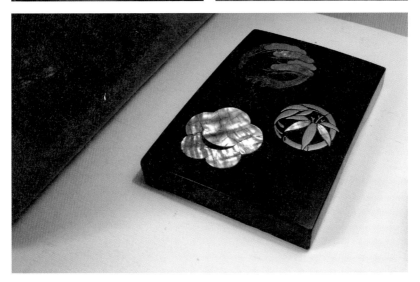

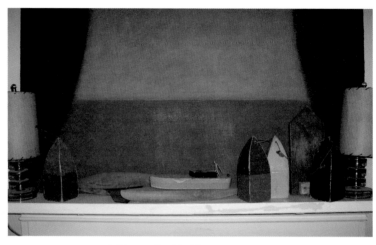

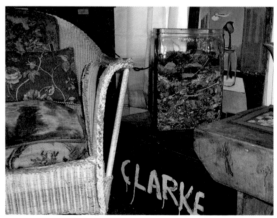

18

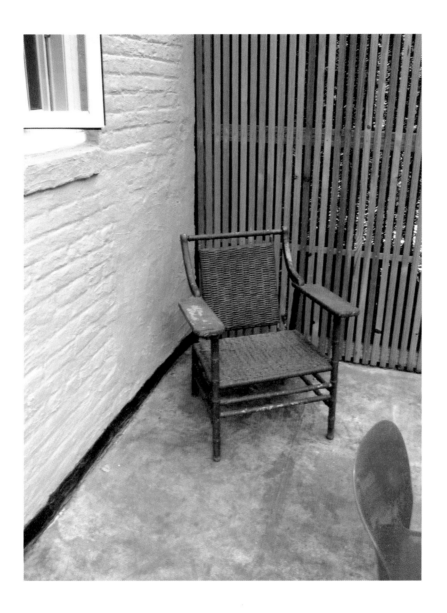

19

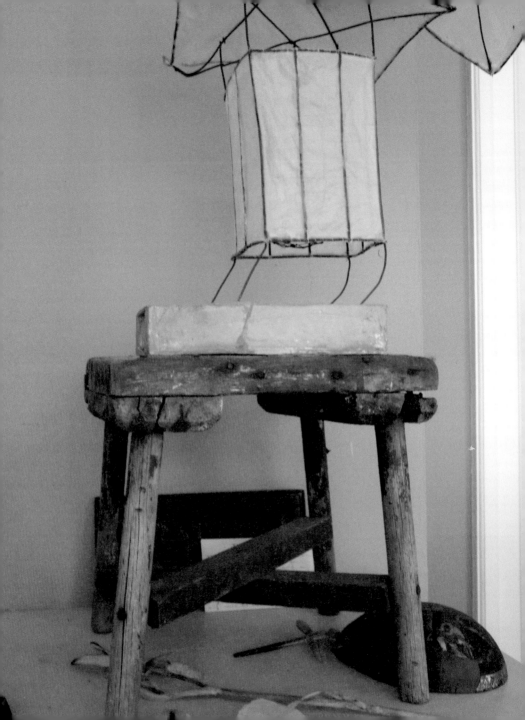

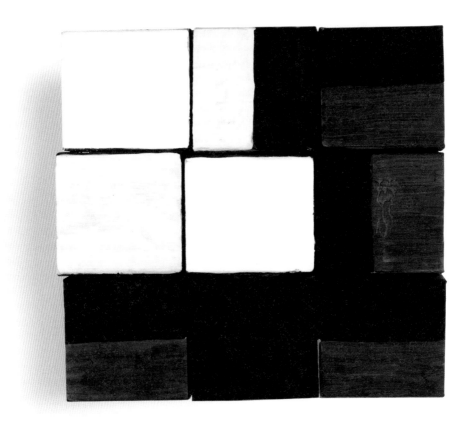

21

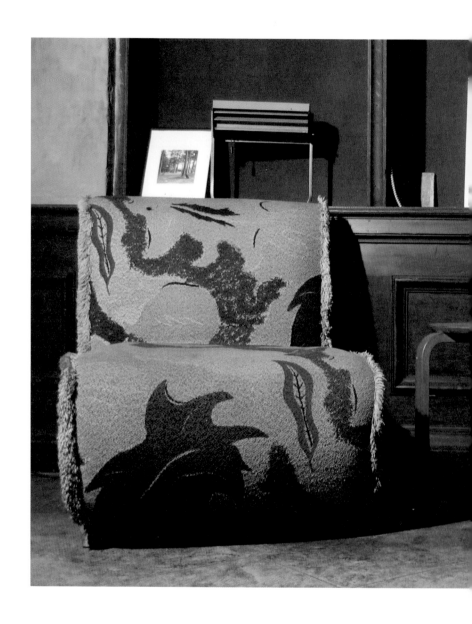

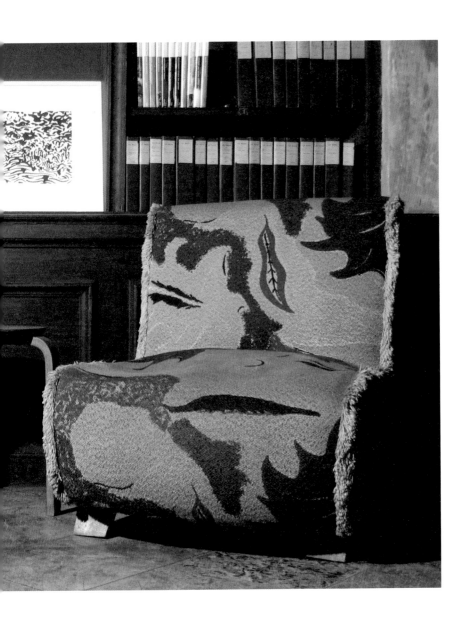

23

Power Type 1910

The Quality 1907

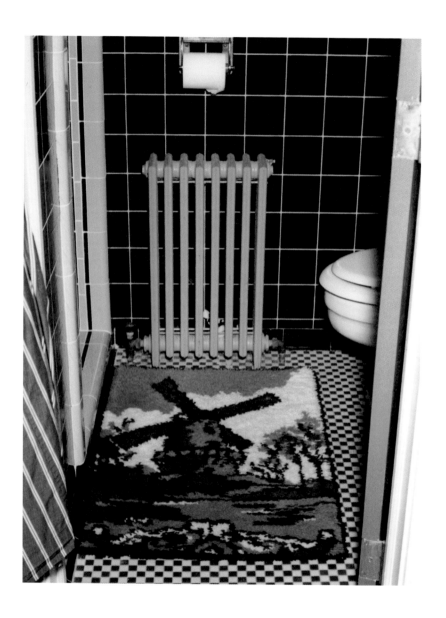

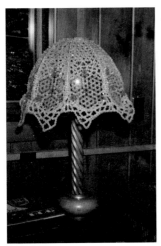 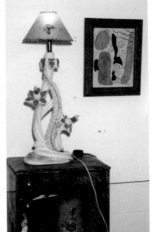 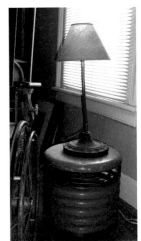

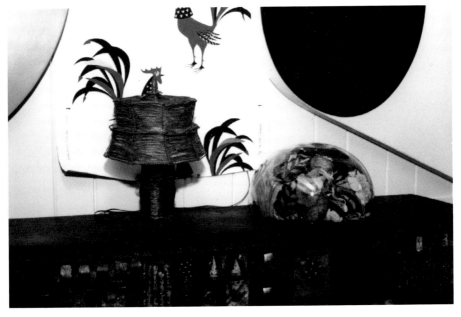

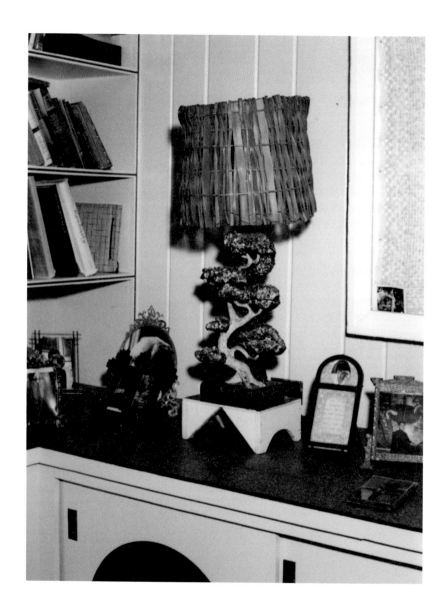

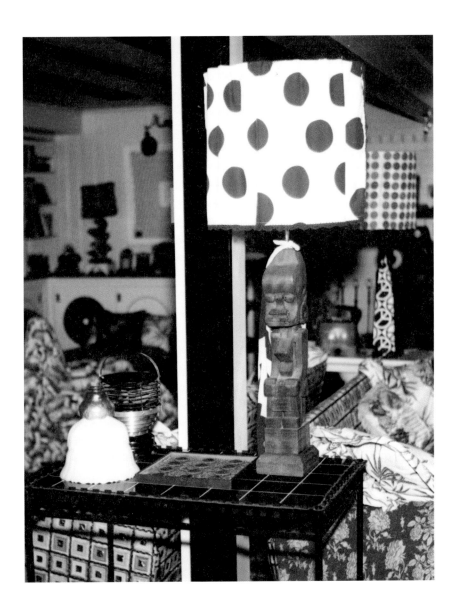

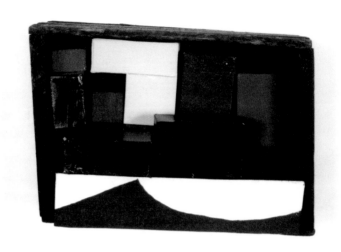

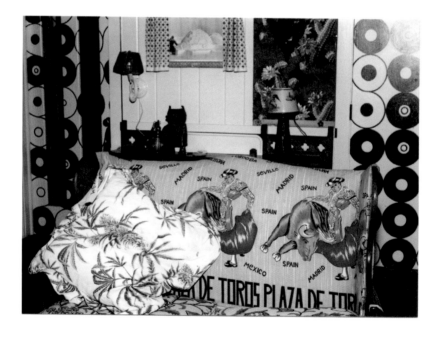

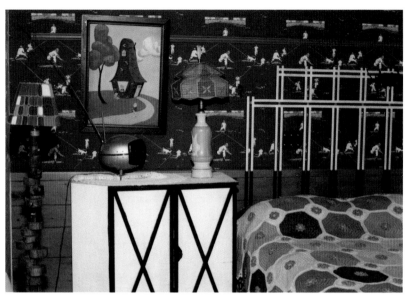

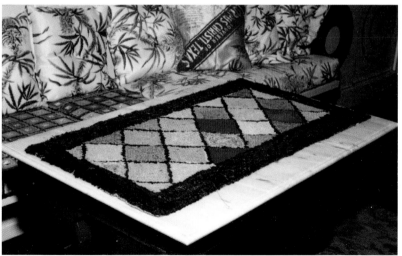

33

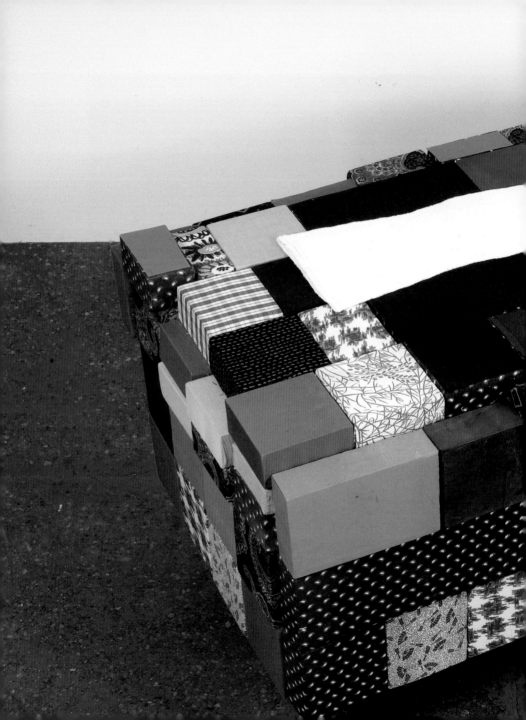

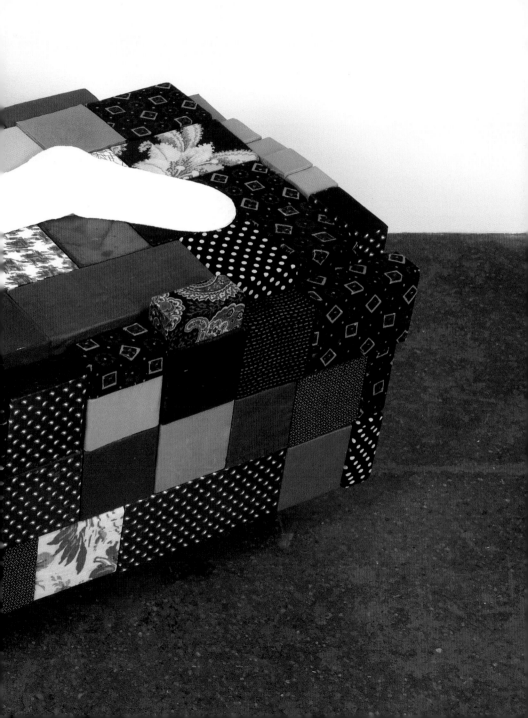

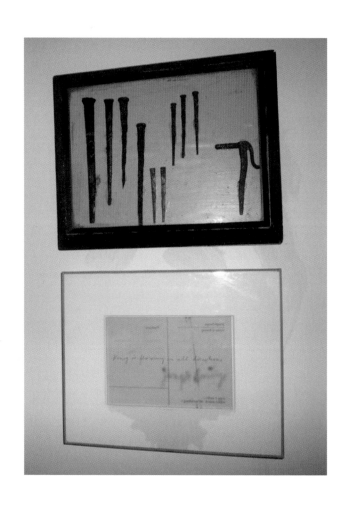

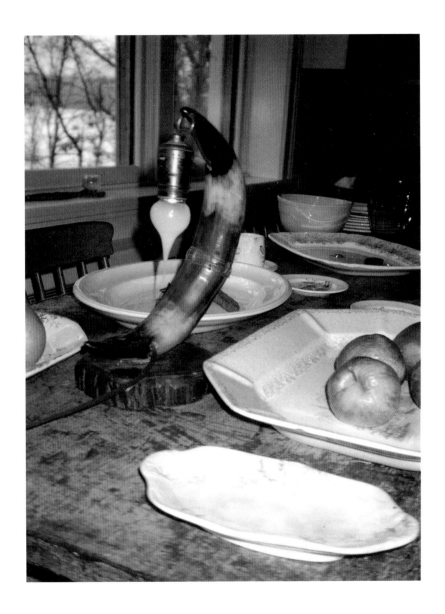

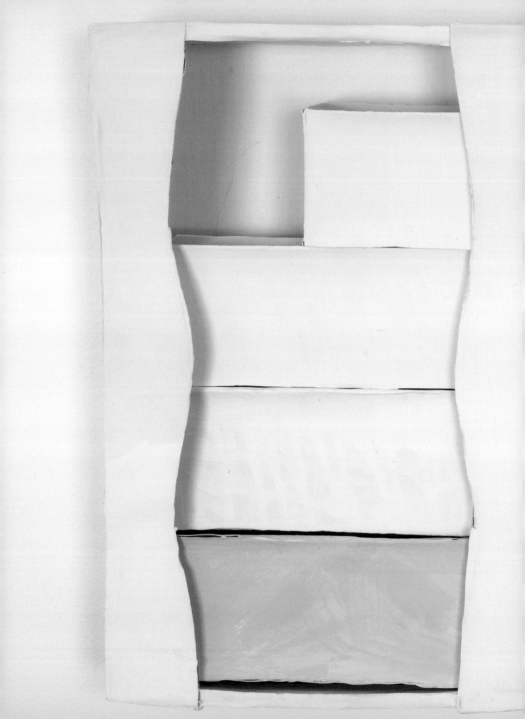

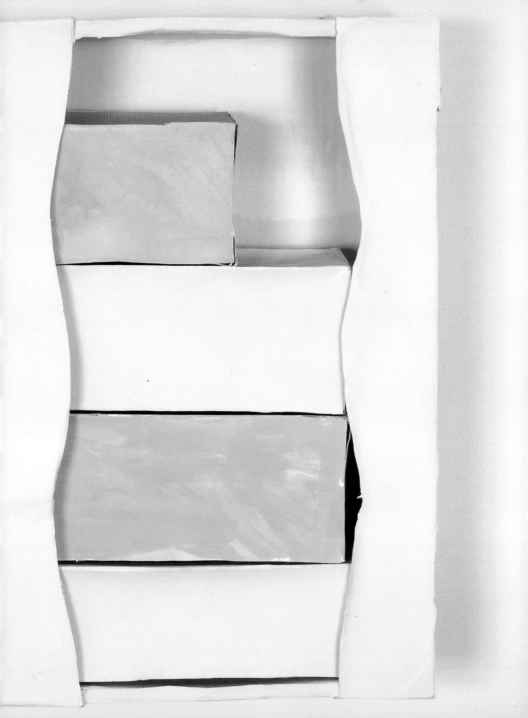

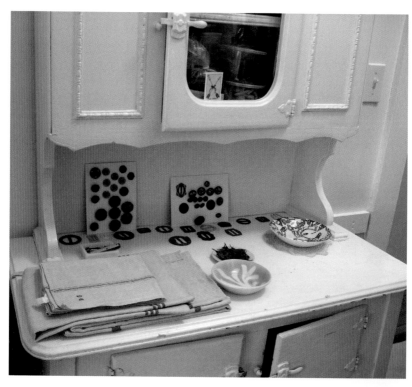

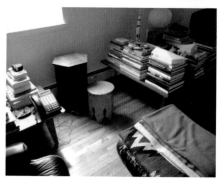

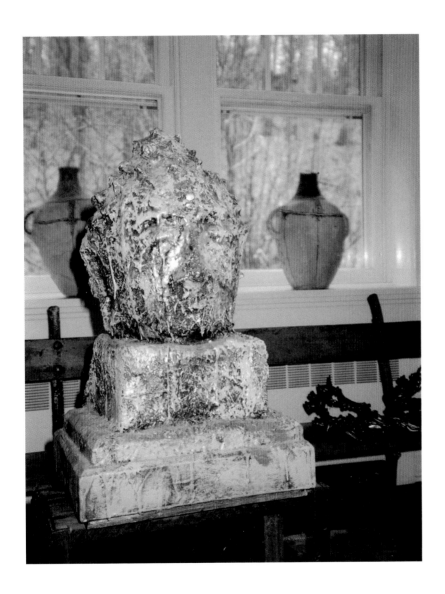

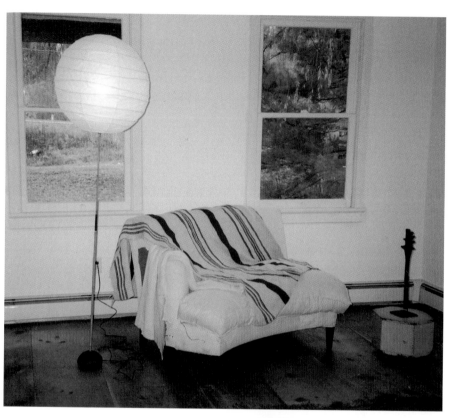

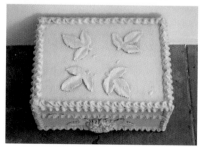

44

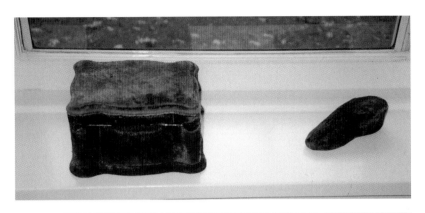

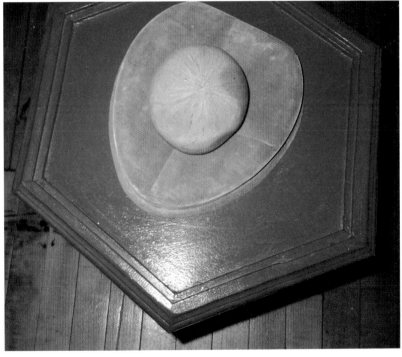

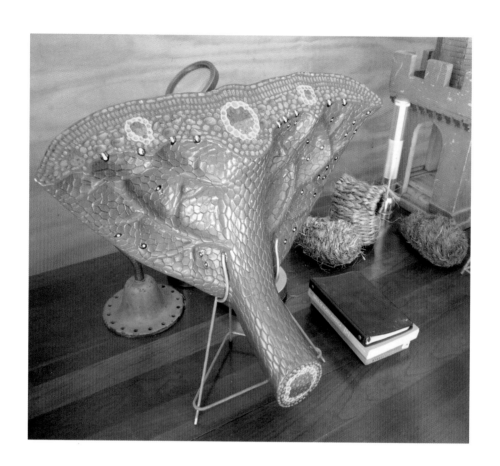

46

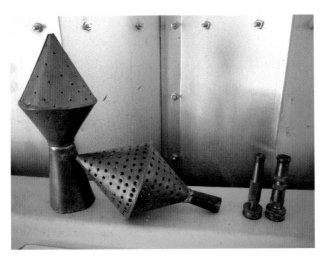

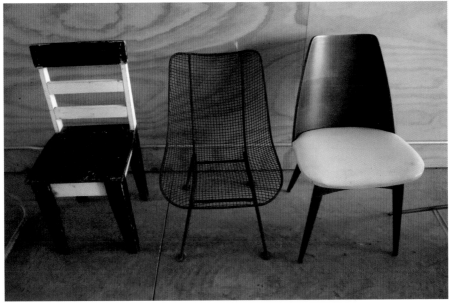

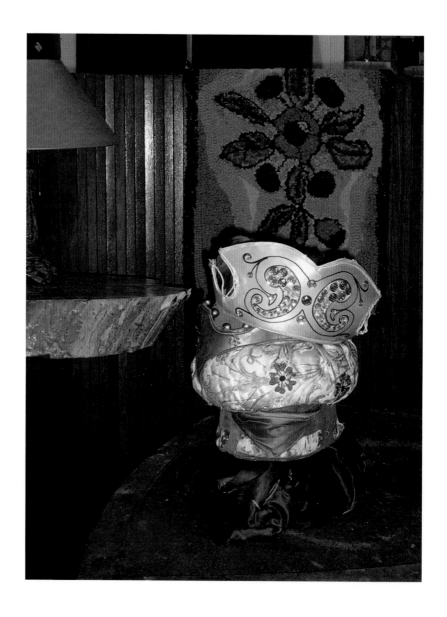

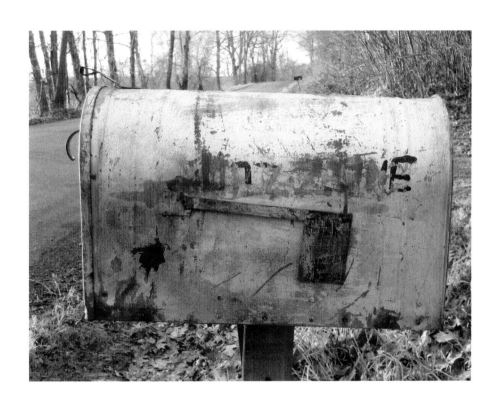

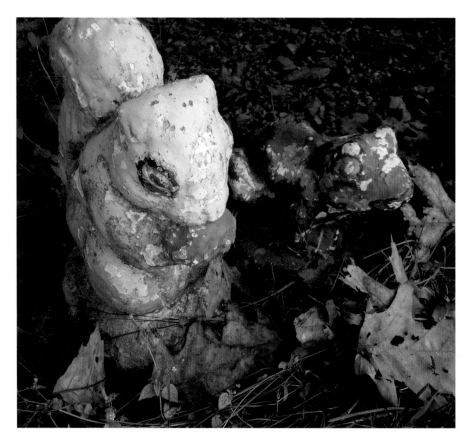

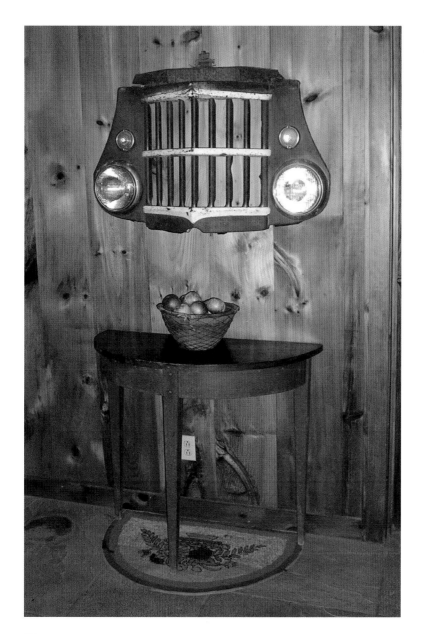

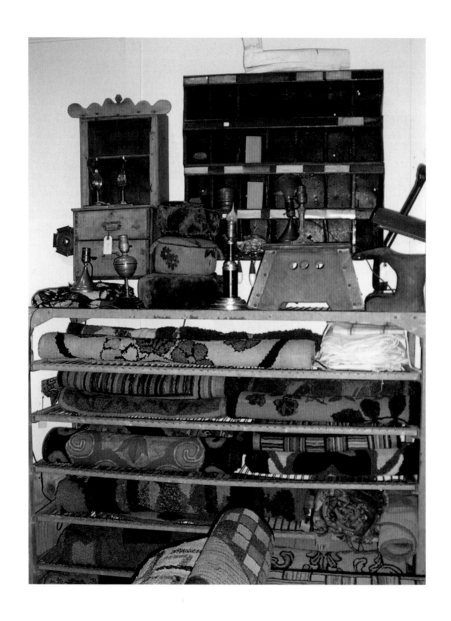

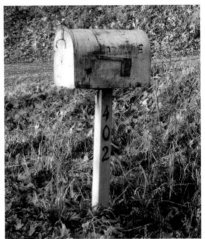

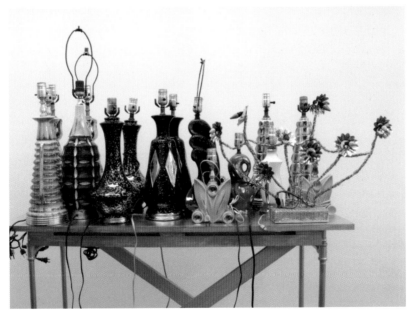

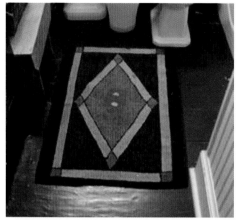

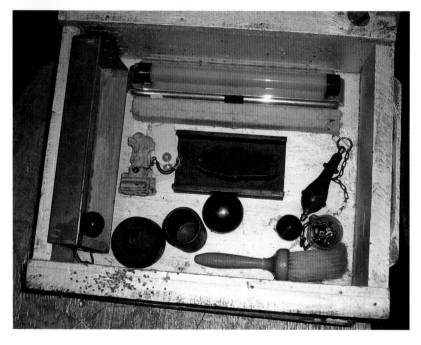

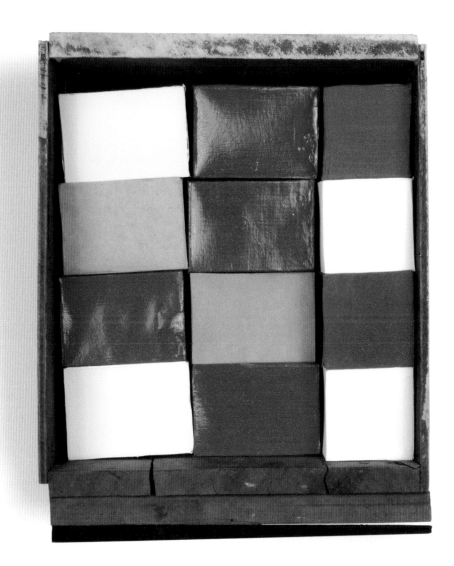

57

Interview with Nancy Shaver by Steel Stillman

The following interview focuses on the lives of objects—in particular on objects noticed, collected, arranged and sold by the artist Nancy Shaver, proprietor of the shop Henry, *in Hudson, N.Y. For Shaver, objects are not inert things. Instead, like characters in a play, they have backstories; onstage relationships—at* Henry—*with other objects; new roles in the homes of their eventual owners; and unknowable futures.*

Collecting is the organizing verb in Shaver's life and work. It is evident in the accumulative grammar of her sculpture and in the exuberant arrangement of her store. For most serious artists, the line between one's art practice and one's day job is easy to mark. In Shaver's case, the line seems blurry until you realize that locating its shifting whereabouts is a productive philosophical matter.

In the images gathered here, and in the conversation below, objects play multiple roles. Aesthetics and ordinary, domestic utility can seem to swap places. Or be the same thing. Beauty shows up unexpectedly. In the end, objects – what they are; how they look; what they signify – are the story. Where art begins or ends is precisely the challenge.

I met Shaver in 1974 when I was one of four or five Middlebury College students who prevailed on her to teach a seminar on photography. We'd heard that she'd been studying with Walker Evans, while her then husband Haim Steinbach, who was also our teacher, was getting his MFA at Yale. Shaver was primarily a photographer then, but she was already a veteran flea market shopper, and a collector of unusual things.

SS: How did you meet Walker Evans? Did he encourage your interest in the ordinary?

NS: Evans was teaching at Yale and I audited his classes. I'd been taking pictures of junk on the ground and on the street, framing things very simply in the viewfinder, and Evans loved my pictures. I'd already begun to understand that if I was going to make art, I'd have to find my interest in what was in front of me. I wasn't interested in high drama or exaggeration. So getting to know Evans and his pictures—and reading *Let Us Now Praise Famous Men*—helped me on my way.

SS: In interviews, Evans repeatedly referred to literature, saying it had been a huge influence on his own work.

NS: In his classes, Evans rarely talked about students' work—all he talked about was literature, about Flaubert, or Baudelaire, or whomever. I decided I had to learn about these people, and read voraciously for the next four or five years.

SS: How often did you and Evans go junking together?

NS: We'd go out once a week. I would have preferred to go to flea markets but he liked more natural settings, like the beach, where he could find things worn by time. He had a huge pair of bolt cutters and he'd steal signs and I'd help. It was fun to find things and give them to him. We had the same kind of eye and became friends.

SS: And when you were on your own, what kind of things were you looking for?

NS: I'd always loved old things, but at Yale my relationship to objects began to evolve. I came to understand that there were hierarchies of objects—in terms of taste, meaning and class. I'd never felt class-conscious growing up, but in New Haven I discovered that society does indeed have a class structure, and that it is reflected in the things people surround themselves with.

We lived a couple of blocks from State Street, where there was a long line of antique stores. I would go every Sunday and look and look; and then I'd buy furniture or other objects. Our apartment became perhaps the most beautiful interior I've lived in. So I learned, for the first time, that taste, or visuality, can trump money. From then on, having a kind of heightened visual understanding became a huge part of my identity. I considered it a form of intelligence, and I hoped to use it—because I wasn't much of a speaker–to demonstrate my sensibilities.

SS: Then, in 1973, you and Haim moved to Vermont, where he got a job teaching at Middlebury.

NS: The Middlebury years were fantastic because I didn't have to have a job. I read piles of books and did extensive junking research. We didn't have a car, but there were church-run junk stores nearby, and I would go almost every day and spend hours looking. It was a visual craving. I had no parameters. I just didn't want to see anything boring. I began looking at children's clothing and toys— at anything that was interesting. And interesting meant being able to look at something the way I now look at a sculpture by Charles Ray: being able to look until you find some seemingly dumb object engendering layer upon layer

of thought. It's a kind of looking where you find yourself thinking about what this object is and how it came to exist and why—about the human desire behind it.

SS: In 1976, you and Haim separated and you returned to New York. It must have been exciting to be back in the city. Did you spend a lot of time going to galleries and museums?

NS: Not that much. I went to thrift stores and spent hours on 14th St, going in and out of the cheap stores, looking at things. That was my research—rather than going to museums.

SS: By the time you moved to Brooklyn, in 1980, your artwork had expanded beyond photography, and you began to make paintings and sculptural arrangements that included the kinds of objects you'd been collecting for years.

NS: I'd bought a falling down house on Adelphi Street for eight thousand dollars. It was unlivable for at least two years, but I made it beautiful. It was a little row house, built in the nineteenth century for workmen at the Brooklyn Navy Yard. I spent every free moment working on it, trying to save money in order to employ people to do what I couldn't. I had a wonderful studio on the parlor floor.

Gradually I began teaching myself to paint, which meant figuring out what my subject was. The first paintings and drawings were still lives and architectural interiors of the house itself. Vernacular and domestic themes. And I began working with objects by just nailing things straight onto the wall: socks, shoes, rubber balls. I was trying to let the objects speak for me.

SS: Were you thinking about your use of objects in relation to the Duchampian found object?

NS: I felt I was appropriating the tradition of the found object and using it for my own purposes. I wanted to present objects in a way that preserved their integrity, while also implying their sociological significance. Though I was using cheap, overlooked objects, they were still rich in meaning. For instance, a cup painted silver spoke volumes about desire—suggesting that silver paint could actually be silver in someone's mind. I was interested in the ordinariness of things, and in the roles they played in people's lives. The fact that most of the objects were old meant that they had histories that could be unraveled. I wanted to bring viewers in, to make them work as hard at understanding each object and the threads connecting one object to another as I had. I wasn't insisting on any one interpretation; I just wanted whatever I made to have a life in the middle space between the viewer and me.

SS: This generation of your work appeared at a time when so-called appropriation art was having its heyday. But, while much of that work took mass culture—and mass-produced objects—as its subject, your eye was on a different kind of ordinariness. Your objects bore traces of the hands that had made and used them.

NS: Sometimes I think of myself as an archaeologist. The objects I'm interested in are not mute and they're not dead. They exist in the realm of story and use; and their use can change, over time, from the practical to the aesthetic, or back again.

SS: How did you become an antiques dealer?

NS: I moved upstate, to Jefferson, New York, in 1990. I was making a modest living from my artwork and I'd had enough of New York. But shortly thereafter, the art market

went into a recession and I was left living in an extremely rural area with no means of support. The only jobs were at Burger King and I'd had enough of waitressing. I did, though, have a talent for finding objects, so I began a business based on that. At first I took space in a multi-dealer shop in Oneonta, and tried selling things at flea markets. It was horribly difficult but I managed to attract a small following. I knew that Hudson, which was about an hour and a half from where I lived, was becoming a mecca for antiques, and that people from New York were going there to buy, so I gathered up two or three friends and together we rented a space and called it Fern. I much preferred having a shop to being an itinerant salesperson. But after a year or two of compromising with my partners on aesthetics and other matters, I opened Henry, and have been in business on my own ever since.

SS: We refer to it as junking, but what is shopping for Henry really like? Has it evolved over time?

NS: Junking is the most incredible experience—rich with visual, political and sociological information. I always feel there is something necessary about it that far exceeds its practical importance. It is one of my great pleasures—even when I don't find anything. My big challenge when I go shopping for Henry is to stay on top of the socioeconomics of the retail world, which means that I constantly have to relearn and readjust my business.

SS: Do you go looking for particular things, or is it more free-floating?

NS: I like it most when I can go out without pre-conceived ideas. What's frustrating about having a business is that I can't just buy anything I like. If I have X, Y and Z in the

shop, I have to buy things that will be compatible, which sometimes puts a kink in my visual experiments.

Here's an example: my favorite thing in the shop right now is a set of plastic fish–they're cartoon-like and sculptural, with bulbous features. They're hand-painted and there are three of them—red, yellow and blue; they're straight out of the '70s. I think they're hilariously funny and exquisitely beautiful, but it's almost impossible to create an audience for that type of thing, unless one is already willing. They're extraordinary art objects and would be the perfect decoration for almost any interior. But it is an uphill battle. If I had a Jean Prouvé table in the shop to put them on, they would be snapped right up. But, since I don't have the Prouvé table, I still have the fish!

SS: As with art, it is a matter of creating, or seducing, an audience.

NS: Right, that's the question: how to seduce an audience? I never feel I'm any good at it, but I keep trying, often kicking and screaming the whole way!

SS: You've lived in three different houses in and around Jefferson—how has living in them, and working on them, affected you?

NS: Though they've taken a lot of my time, houses and interiors have played a huge role in my life. They've taught me a great deal about space and light and color. And because I've never had any money, but have always wanted to have art, my houses have taught me about looking. It is because of them that I learned how to find some bit of trash on the street—something my eye told me was beautiful – and create a setting that transformed it into art. Henry comes out of that experience.

My houses have been laboratories for visual encounters that I wouldn't have had any other way. For instance, for several years I lived in a barely renovated barn, which sat in the middle of a meadow like a big boat. During that time, I became convinced that Persian carpets had been invented in response to the sight of meadows filled with spring wildflowers. My discovery was instantaneous and visceral and was not based on art history. This was not something I'd read about, it was something I saw!

SS: For nearly a decade, you stopped using found objects in your artwork. But in the mid-'00s, you brought them back. One striking example might be the rocking chair you used for a piece in the exhibition "Retail" at Feature, in 2007.

NS: It's been something of a surprise to be working with objects again. And it's developed out of the back and forth between Henry and my artwork. Occasionally it happens that I buy something, thinking it is for the shop, and before even putting it in the car, I discover that it has jumped categories, that it has gone from being a Henry object to something I want to investigate for my art.

In the case of the rocking chair, it was a modern, mid-20th century, tubular steel chair that the manufacturer had turned into a rocker by adding wooden runners. Someone had decided to take this ultimate modern object and marry it to an idea of comfort from an earlier age. The chair I found was a beautiful and puzzling thing, an oxymoron really—a crude version of an idea the Eameses had also had. I took the rocking chair to Henry and put it in the window and knew instantly that nobody would buy it—it

had jumped categories. It lived for a number of years in my studio before I figured out what to do. Eventually I draped a piece of raw silk, which I had drawn on with black ink, over its back; the resulting intervention felt less like an addition than a completion.

The rocking chair piece is an example of the way I interweave history, art history and the everyday. This chair had originated in an idea of modernity developed by Corbusier and others. Its design was then adapted for the masses, for whom it was made in factories and sold at local furniture stores. At the same time, my use of this chair is in a direct line from Duchamp's readymades—though he would roll over in his grave if he knew about it. And while I've had to make it more retinal, to use Duchamp's word, in order for it to be seen as a readymade, what I am doing is stealing from art history and raising the ante. Art often comes about in reaction to other art, and I find pleasure and humor in building on, and contradicting, what has come before. Good art is full of contradictions.

SS: As an exhibition, "Retail" seemed to echo what you do at Henry every day.

NS: A friend of mine says that art is only for elites, that it requires a specialized interest and sensibility. But I don't think that's true, and proving that it isn't was my motivation for "Retail." The job at Henry is to present objects that are beautiful and that have visual value, regardless of their price. I wanted to do the same thing at the gallery: to flatten the hierarchies that divide art from non-art, to dirty the white walls. I wanted the experience of visuality to be what hit

you, like a blast in the eye, when you walked in the door. My aim was to create an overload of visual information.

Doing my research for "Retail," I realized that Braque, Picasso and Matisse, for all the differences in their thinking, had also found their visuality in shops like mine. There is a long history of this kind of search for, and use of, beauty.

SS: Do you ever worry about confusing your audience? Or do you think of confusion as a positive value: bringing together—as the word itself suggests—things normally kept apart?

NS: It is hard for me to be fully aware of the kind of confusion I create. I live in a world without categories. For me, confusion is exciting. But I understand that it makes other people uncomfortable.

The preceding exchange is adapted from a longer, unpublished interview from 2009 that expands more broadly on Shaver's artwork and its development.

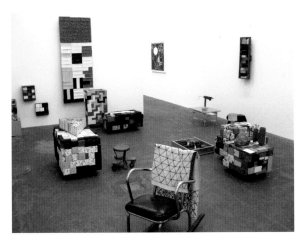

Installation view of "Retail" at Feature Inc., 2007. Photo: Jason Mandella.

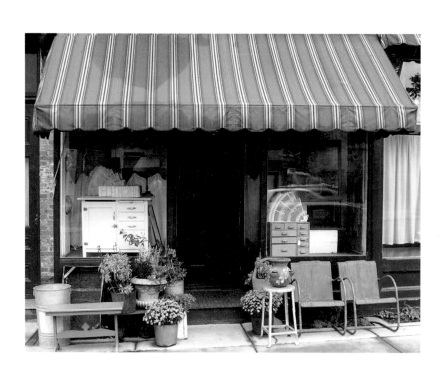

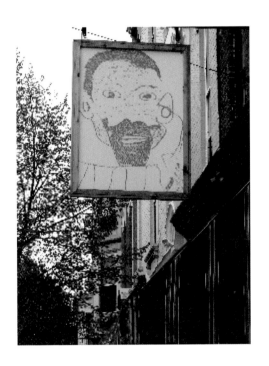

Object and Image Credits

Except where noted otherwise, all images were taken in 2007.

page 1 • Henry interior, 2006. Photo: Steel Stillman.
page 2 • Nancy Shaver studio, 2010. Photo: Nancy Shaver.
page 8 • Home of Jean-Phillipe Antoine (fabric). Photo: Jean-Philippe Antoine.
page 9 • Home of Jean-Phillipe Antoine (cartoon hooked rug and bedcover). Photo: Jean-Philippe Antoine.
page 10 • Home of Jane Ayers and Steel Stillman [(top) hooked rug and croquet storage unit; (bottom) wood splitting tool and reflective "S"]. Photos: Jane Ayers.
page 11 • Home of Jane Ayers and Steel Stillman (rhinestone collar). Photo: Jane Ayers.
pages 12+13 • [left] Home of Jane Ayers and Steel Stillman (tin, metal vase and teapot). Photo: Jane Ayers. [right] Home of Lynn Sloneker and Stephen Courbois (chairs). Photo: Lynn Sloneker.
page 14 • Home of Ann Bobco and Bill Wurtz (cabinet of drawers). Photo: Ann Bobco.
page 15 • Home of Ann Bobco and Bill Wurtz (mirror). Photo: Ann Bobco.
page 16 • Home of Ann Bobco and Bill Wurtz (oil lamps and candle stick). Photo: Ann Bobco.
page 17 • Home of Ann Bobco and Bill Wurtz [(top left) 20's plastic lamp; (top right) puzzle piece hooked rug; (bottom) Japanese lacquer box]. Photos: Ann Bobco.
page 18 • Home of Lynn Sloneker and Stephen Courbois [(top) buoys; (bottom) Clarke storage box and battery acid jar]. Photos: Lynn Sloneker.
page 19 • Home of Ann Bobco and Bill Wurtz (wicker chair). Photo: Ann Bobco.
page 20 • Home of Ann Lauterbach (primitive wooden stool with *how to fly* by Augusta Talbot), 2008. Photo: Nancy Shaver.
page 21 • *Assortment: black and white*, 2006, by Nancy Shaver. Photo: Jason Mandella.
pages 22+23 • Home of David Deutsch (upholstered chairs). Photo: Megan Wurth.
pages 24+25 • Home of Timothy Dunleavy (photographs). Photo: Timothy Dunleavy.
page 26 • Home of Joe Holtzman, c. 2007 (windmill hooked rug). Photo: Nancy Shaver.
page 27 • Home of Joe Holtzman, c. 2007 [(top left) beaded lampshade; (top right) plaster lamp, painted cupboard with roses and fabric; (bottom) fabric, wire lamp and lampshade, glass dome]. Photos: Nancy Shaver.
page 28 • Home of Joe Holtzman, c. 2007 (plaster tree lamp, base of lamp=white handmade stool). Photo: Nancy Shaver.
page 29 • Home of Joe Holtzman, c. 2007 (fabric, lampshade, box, shell vase). Photo: Nancy Shaver.
page 30 • [top] *Crooked box, white curve*, 2006, by Nancy Shaver. Photo: Jason Mandella. [bottom] Home of Joe Holtzman, c. 2007 (Spanish fabric, plastic lamp, and lamp shade). Photo: Nancy Shaver.
page 31 • Home of Joe Holtzman, c. 2007 (Modernist painting). Photo: Nancy Shaver.
page 32 • Home of Ann Bobco and Bill Wurtz (brick-patterned hooked rug). Photo: Ann Bobco.
page 33 • Home of Joe Holtzman, c. 2007 [(top) cupboard, painting, bedspread; (bottom) diamond hooked rug]. Photos: Nancy Shaver.

page 34+35 • *Flat Goods*, 2006, by Nancy Shaver. Photo: Jason Mandella.
page 36 • Home of Handel Teicher and Terry Winters (collection of hand forged nails). Photo: Terry Winters.
page 37 • Home of Brice and Helen Marden (horn lamp). Photo: Helen Marden.
page 38+39 • *Fruit Box #1*, 2005, by Nancy Shaver. Photo: Jason Mandella.
page 40 • [top] Home of Holly Hughes (buttons and buckles). Photo: Holly Hughes. [bottom] Home of Handel Teicher and Terry Winters (Islamic style tables). Photo: Terry Winters.
page 41 • Home of Holly Hughes (canteen). Photo: Holly Hughes.
page 42 • Unnamed Home (painting).
page 43 • Home of Brice and Helen Marden (Buddha head made of candle wax). Photo: Helen Marden.
page 44 • [top] Home of Brice and Helen Marden (red+white striped blanket and sofa, octagonal stool). Photo: Helen Marden. [bottom] Pink leather box from "Retail" at Feature Inc., 2007. Photo: Jason Mandella.
page 45 • Home of Brice and Helen Marden [(top) velvet box; (bottom) gray velvet box and gray silk pin cushion]. Photos: Helen Marden.
page 46 • Home of Handel Teicher and Terry Winters (model of leaf structure). Photo: Terry Winters.
page 47 • Home of Handel Teicher and Terry Winters [(top) irrigation guards; (bottom) black + white chair]. Photos: Terry Winters.
page 48 • Henry interior (ceremonial hats from the Masons organization and flowered hooked rug), 2006. Photo: Steel Stillman.
page 49 • Home of David Davenport (large mailbox). Photo: David Davenport.
page 50 • Home of Handel Teicher and Terry Winters (concrete squirrel + frog). Photo: Terry Winters.
page 51 • Home of Betsy Miller (Jeep grille). Photo: Betsy Miller.
page 52 • Henry interior (miscellaneous objects), 2006. Photo: Steel Stillman.
page 53 • Henry interior (collection of forms), 2006. Photo: Steel Stillman.
page 54 • Henry interior (table, hand-made coiled ceramic vase), 2006. Photo: Steel Stillman.
page 55 • [top left] Henry interior (Victorian metal lamp, table). Photo: Nancy Shaver. [top right] Home of David Davenport (large mailbox). Photo: David Davenport. [bottom] Collection of Modernist lamps from "Retail" at Feature Inc., 2007. Photo: Jason Mandella.
page 56 • [top left] Home of Ann Lauterbach (geometric hooked rug), 2008. Photo: Nancy Shaver. [top right] Henry interior (wagon jack, homemade picture), 2006. Photo: Steel Stillman. [bottom] Henry interior (collection of small objects), 2006. Photo: Steel Stillman.
page 57 • *One blue block, red brick*, 2004, Nancy Shaver. Photo: Jason Mandella.
page 68 • Henry exterior, 2006. Photo: Steel Stillman.
page 69 • Henry sign, 2010. Photo: Nancy Shaver.
page 71 • Nancy Shaver studio, 2010. Photo: Nancy Shaver.
page 72 • Henry interior, 2006. Photo: Steel Stillman.

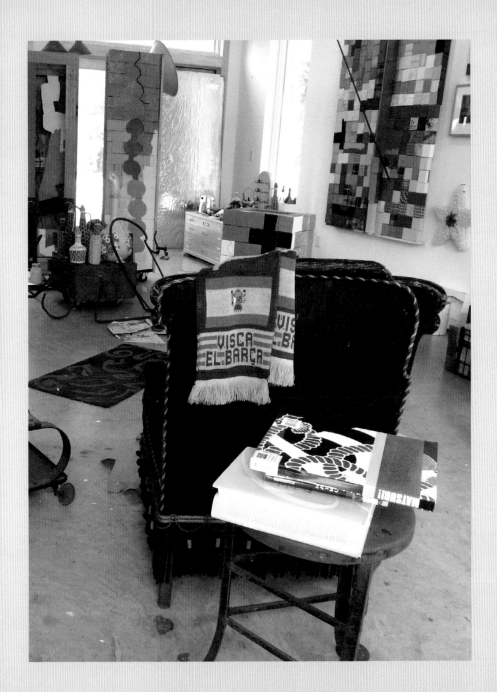

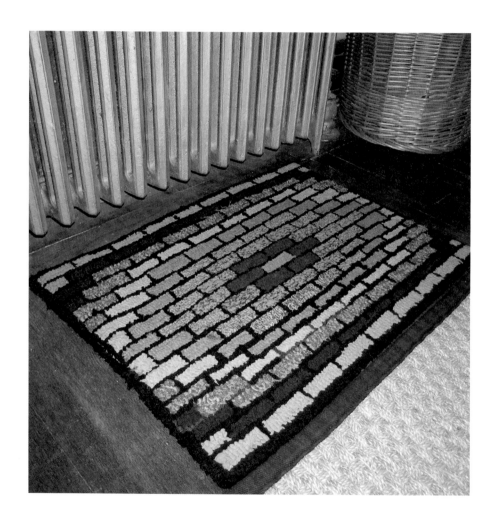